101
Glimpses of the
Old Man
of the Mountain

101

Glimpses of the

Old Man
of the Mountain

BRUCE D. HEALD
WITH DAVID C. NIELSEN, CARETAKER OF
THE OLD MAN OF THE MOUNTAIN

Charleston — London

THE
History
PRESS

Published by The History Press
Charleston, SC 29403
www.historypress.net

First published 2009
Second printing 2011
Third printing 2012

Manufactured in the United States

ISBN 978.1.59629.630.5
Library of Congress Cataloging-in-Publication Data

Heald, Bruce D., 1935-
101 glimpses of the Old Man of the Mountain / Bruce D. Heald with
David C. Nielsen.
p. cm.
ISBN 978-1-59629-630-5
1. Old Man of the Mountain (N.H.) 2. Conservation of natural
resources--New Hampshire--Old Man of the Mountain. I. Nielsen,
David C. II. Title.
F41.6.P9H43 2009
974.2'3--dc22
2009001703

CONTENTS

Letter from the Governor

Dear Friends:

For centuries, the Old Man of the Mountain watched over New Hampshire from his perch in Franconia Notch. Over the years, the Old Man has come to represent New Hampshire and all that is special about our state. It has been part of the official state emblem since 1945 and is the symbol of New Hampshire in the minds of people throughout the world.

The Old Man was always a clear reminder of the power and beauty of nature. Sadly, on May 3, 2003, the combined effects of years of rain, wind, snow and gravity overcame the Old Man, which fell from the face of Cannon Mountain.

Even though the stone that formed the Old Man has fallen from the mountainside, the symbol lives on in memorials, tributes and the memories of all who saw the

majestic face. The Old Man served as a link between us and past citizens of New Hampshire, and by sharing our memories of the Old Man with the next generation, we can all help to keep this great symbol of New Hampshire alive.

Sincerely,

John H. Lynch
Governor

FOREWORD

It was the summer of 1969 when Pop came into my room and woke me before sunrise. "Get up. Today's the day that we give the Old Man a shave and a haircut." I was eleven and had no idea how this day would affect the rest of my life. My three brothers, Thomas, Robert and Michael, had helped before. But the Old Man would turn out to be my passion.

The first preservation work on the Old Man was completed in 1916 by Edward Geddes and Reverend Guy Roberts in order to secure the forehead stone. In 1958, engineers installed turnbuckles, built a water diversion wall and added a fiberglass cap over a large crack.

In 1960, my father, Niels F.F. Nielsen Jr., made his first trip to the Old Man as a member of a work party for the State of New Hampshire Department of Transportation. In 1987, he became the official caretaker, appointed by Governor John Sununu. I would succeed him in 1992, appointed by Governor Judd Gregg.

In 1983, I brought Deborah Goddard to the Old Man for our second date. We would later be married. She became the first woman to work over the side of the Old Man. When my father retired from the work, she became my partner both on and off the mountain. Our son Thomas would later take his first trip to the Old Man at the age of nine.

Ever year we measured, weighed and inspected the Old Man. We calculated and graphed the movements of the layers of rock. Annual repairs included creating and maintaining protective fiberglass barriers. The metal turnbuckles were painted each year to prevent rust. Only Pop, Deb and I worked over the edge, but our work could not have been completed without the help of volunteers. Over the years, hundreds offered sweat, tears and hard work to the Old Man, keeping him secure.

Visiting the site was always memorable, but one trip stands out. While perched on the tip of the Old Man's chin one day suspended from a cable, a gust of wind came between the mountain and me. As the gust lifted me off the surface, I was able to look straight down, about five hundred feet to the cliffs below. It seemed as if I was suspended in air for an eternity. The wind then gently settled me back on the mountain. I was sure that my heart had stopped. After several anxious moments, I returned to the top of the Old Man's head.

Later, I described the experience to Pop and asked if it had ever happened to him. "No," he said, "but I know what

happened. God reached out, picked you off the mountain and whispered in your ear. Then he gently put you back." It was a life-affirming moment.

On our work trip in 2002, Pop's ashes were placed into the Old Man's left eye; this was one of his last wishes. We could not have known that the Old Man would fall on May 3, 2003. They now lie together for eternity on the talus slopes of Profile Mountain.

My father and I never intended to gain fame, fortune or notoriety for our efforts. We were raised to believe that everyone should find a way to pay back the community for the privilege of living here. This was our way of paying back.

David C. Nielsen
Official Caretaker of the Old Man of the Mountain

INTRODUCTION

The Great Stone Face in Franconia Notch

A masterpiece of nature's caprice once appeared in Franconia Notch. The Old Man of the Mountain, perched fourteen hundred feet above Profile Lake on the edge of Cannon Mountain, cast a solemn gaze upon the scenic and rugged notch and enthralled travelers for generations. The great stone face was considered stable, especially after years of care and reinforcement by skilled engineers. But on May 3, 2003, the unthinkable happened: the Old Man fell from the mountain. To better understand its long history, let us examine the efforts to preserve the Old Man and study the geological formation of the notch.

The Old Man Is Born

At the end of the Devonian Period, approximately 360 million years ago, an ancient mountain range formed from

magma that seeped through the earth's crust. Crystallizing slowly, it formed what we know as Kinsman granite, the oldest exposed rock in New Hampshire. The region—together with other northern latitudes around the globe—was covered by a massive ice sheet during the last ice age, and when it receded it scoured the peaks and floor of the notch. On Cannon Mountain, according to Charles Hitchcock's 1874 work, *The Geology of New Hampshire*, the rough bottom of the ice sheet cracked the granite cliffs, allowing rain and snow to gather. As the precipitation froze and expanded, he wrote, it formed wedges of ice that slowly split the cliff:

> *Frost action forced blocks of granite to fall from the cliff. As they fell, some from one place, some from others, the remaining ledges gradually assumed the details of the present profile. The face was made of several separate and independent ledges so arranged horizontally along a cliff completely by chance that, when viewed from precisely the right angle, they blended together to produce the face of the Old Man. Finally… the block of granite, which formed the top of the face, separated from the main part of the cliff and tilted outward several feet until it completed the forehead.*

Erosion occurred throughout the notch, changing its shape from an original "V" to the present, graceful "U." But no other mountaintop witnessed a change as great as

did Cannon Mountain. Its great stone face even led many to refer to the peak as Profile Mountain, bestowing a second name upon Franconia Notch's most beloved feature.

Under Study

Engineers and geologists examined this unique arrangement of granite ledges many times, studying the secret to its stability and looking for signs of weakness. Interest in the Old Man's safety increased during the early 1950s, when road crews began work on an extension of Interstate 93 on the floor of the notch. Responding to concerns that the use of dynamite and heavy machines could cause the profile to crumble, state officials commissioned a study by two University of New Hampshire scientists. The only existing measurements of the Old Man had been taken by Edward Geddes in 1937. This report, issued in 1954 by Professors Skelton and Mayers, revealed that a crevice documented by Geddes had widened by three-quarters of an inch. The top of the Old Man's head, estimated to weigh more than three hundred tons, appeared to be slowly separating from the mountain.

These findings led to the design and installation of four large turnbuckles, which secured several loose boulders, and the sealing of several small cracks with epoxy. Waterproofing and Engineering Products Company of Revere, Massachusetts, began the work in July 1958.

Workers also constructed a sluiceway in the back of the head and sealed the widening crack with a waterproof epoxy. Rain, wind and ice posed constant threats, but the crew completed the project without incident in just ten weeks.

Around the same time, the New Hampshire Forestry and Recreation Commission engaged the services of Edward B. Burwell Jr., a former chief geologist for the United States Army Corps of Engineers. Burwell was asked to determine a long-range strategy for preserving the Old Man, and he made a research trip to the site in the summer of 1958. He reported that the granite mass forming the profile was divided by three sets of joints, or fractures, into an assemblage of blocks of various dimensions arranged to form a crude cantilever. Burwell cautioned that he knew of no method whereby the stability of this balancing act could be preserved. The Old Man, he wrote, appeared to be in a precarious state.

The commission sought additional advice in the fall of 1958, appointing a three-man advisory board composed of Burwell, Arthur Casagrande and John W. Vanderwilt. Casagrande was a professor of soil mechanics and foundation engineering at Harvard; Vanderwilt was president of the Colorado School of Mines. Together, they outlined two possible strategies. First, considering the very small movement that had been measured in recent years, they considered the probability of an imminent collapse unlikely and thus argued that reasonable expenditures

intended to strengthen the profile may be worthwhile. On the other hand, they noted, if the structural integrity of the granite blocks was low, even a small tremor might cause a collapse. If this case, only very expensive and dangerous measures might prolong the Old Man's life. Weighing these scenarios with data from the just-completed weatherproofing project, the board asserted that the most urgent and obvious measures to stabilize the forehead ledge had already been completed. They unanimously recommended that "nothing more should be done to the ledges until further information is obtained."

A follow-up study of the 1958 installations found that they had survived the winter in "excellent condition." From this point, state engineers would visit the site once a year to take measurements to determine possible movement in the forehead blocks. As for concern over blasting related to road construction, which spurred the studies, the board agreed that the vibrations were not sufficient to dislodge the profile.

Nevertheless, after the three-man board disbanded, the Department of Public Works and Highways, in cooperation with the United States Department of Transportation, initiated a three-phase seismic monitoring program. At a cost of $90,000 (with 90 percent assumed by the federal government), the department began testing in June 1968. Phase I of the investigation was started by a four-man team headed by seismologist Wendell V. Mickey.

To reach the test site, Mickey's team had to climb to the top of Cannon Mountain, then hike some 1,100 feet down to the Old Man to install seismometers on the profile ledge. They also placed sensors some distance away from the face to record simultaneous vibrations and thereby evaluate the relative stability and responses of each major part of the site. Mickey installed a dozen temporary seismometers during the first visit. During Phase II, four permanent installations were added. Finally, in Phase III, the units were connected by four-thousand-foot cables to a recording station located beside Route 3, on the floor of the notch, where film records would be made twenty-four hours a day for three years. In order to permit comparison of man-made disturbances with those occurring naturally, a series of test blasts was made and recorded. Records from the seismograph station were then forwarded to headquarters of the United States Coast and Geodetic Survey in Rockville, Maryland.

In his first report on the result of Phase I observations, Highway Commissioner Robert H. Whitaker stated that "as a result of the analysis of the 26 tests performed on the Profile, one can be confident that highway construction blasts can be designed to produce vibration levels at the Profile far below those experienced from natural sources." The report noted that the predominant natural vibration input came from the wind. Road construction would not threaten the great stone face.

Yet the initial report, issued in 1969, reminded the state that the struggle to save the Old Man might be futile.

Materials and Research engineer Paul S. Otis wrote, "Natural forces are at work against 'The Old Man' and I'm afraid that they will eventually emerge victorious." The formation had been tied together with steel rods and turnbuckles, and a plastic cover had been installed over a fissure in the forehead.

The Caretakers

Niels F.F. Nielsen Jr. joined the New Hampshire Highway Department in 1960 and soon began participating in inspection trips. In 1965, he became the leader of the work party charged with visiting the Old Man. Through repeated trips to the site, Nielsen grew increasingly concerned about two large cracks in the south face. Burwell and others had focused on an upper crevice, now sealed from the elements. But Nielsen noted that the other cracks remained exposed to wind and rain from the south. Moreover, he observed, rain and snow collected in these openings and had little opportunity to drain or evaporate before cool temperatures caused them to freeze.

Nielsen found support for his concern in a report produced by researchers from Dartmouth. The authors surveyed the Old Man's profile and determined that the Adam's apple, or keystone, provided essential support for the cantilevered arrangement. If this keystone were lost, they noted, the Old Man could not hold together. Nielsen

gave much thought to the question of how to reinforce the Adam's apple, keeping in mind that work conducted under the Old Man's chin would be highly dangerous. Ultimately, he proceeded with the reinforcements.

The condition of the Old Man continued to change. Nielsen later benefitted from the help of his son, David, and daughter-in-law, Deborah; together with other volunteers, the Nielsens continued to patch up the Old Man the best they could. Over time, they believed that they were gaining in their battle with nature and its violent elements. The battle they were losing was with the thoughtless vandals who continued to carve initials in the rocks and destroy vital testing equipment. But against challenges both natural and man-made, they tirelessly strove to preserve the Old Man for future generations.

The Old Man owed its creation to nature, but survival in its later years could be attributed to this family and the many volunteers who joined them at the profile's edge. They helped recent generations form fond memories of the Old Man, that great stone face that was so proudly displayed on Profile Mountain in Franconia Notch.

All effects of light and shadow are so many changes of expression. We have seen the face cut sharp and clear as an antique cameo upon the morning sky. We have seen it suffused, almost transfigured in the sunset glow. Often does a cloud rest upon its brow. We have seen it start fitfully out of the flying scud to be the next

moment smothered in clouds. We have heard the thunder roll from its lips of stone. We recall the sunken cheeks, wet with the damps of its nightlong vigil, glistening in the morning sunshine—smiling through tears. We remember its emaciated visage streaked and crossed with wrinkles that the snow had put there in a night; but never have we seen it insipid or commonplace. On the contrary, the overhanging brow, the antique nose, the protruding under-lip, the massive chin might belong to another Prometheus chained to the rock, but whom no punishment could make lower his haughty head.

We linger by the margin of the lake watching the play of the clouds upon the water—all is silent.

—Samuel Adams Drake (1882)

THE HISTORY OF THE
GREAT STONE FACE

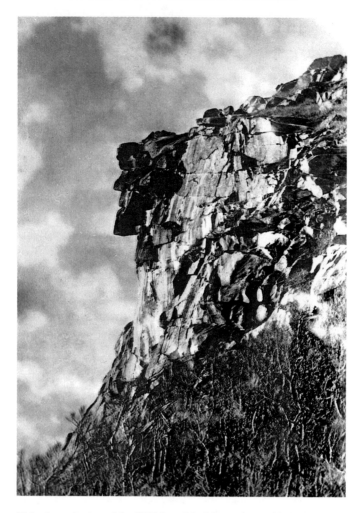

This telescopic view of the Old Man of the Mountain graphically illustrates the profile's composition. It was formed during an ice age and was worshipped by the Native Americans as the profile of the "Great Spirit."

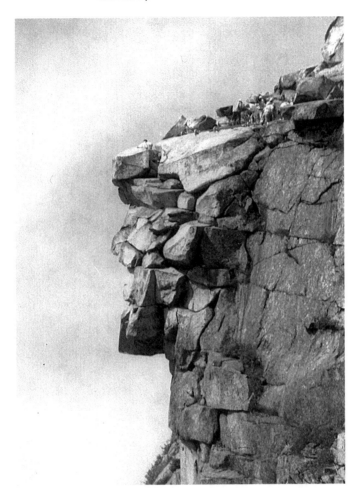

Mother nature often measures men by manifestations of her inscrutable dominance of the world. So it is with the Old Man, who presides in granite grandeur over New Hampshire's White Mountains in the silent serenity of measureless time and wonder.

A scene of the first settlers of the White Mountains. Millions of travelers have gazed with admiration upon that stern and stately visage of Profile Mountain (Cannon Mountain), which looks down the valley from its lofty height of fourteen hundred feet above Profile Lake.

Some writers claim that the Old Man was discovered long before the white settlers, perhaps as early as 1640. The region was a favorite haunt of the Native Americans, and it is stated that friends of John Stark made the first discovery while searching for him after his capture by the Indians.

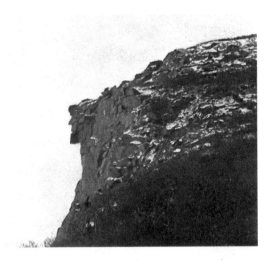

The profile of the great stone face as seen from the highway. According to M.F. Sweetser, "The discovery of the Old Man was made in 1805 by Francis Whitcomb and Luke Brooks."

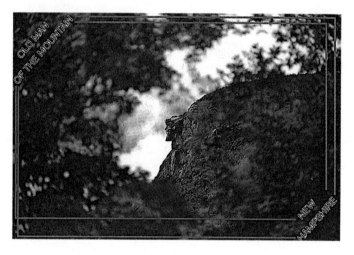

Profile of the Old Man on Profile Mountain, which is part of Cannon Mountain. According to F.M. Kilbourne, "Dr. W.C. Prime, a long resident of the Franconia region, said that Franconia tradition among the older residents credits the discovery to a Baptist minister from Lisbon who was traveling that way by the lake, and glancing up, saw the face."

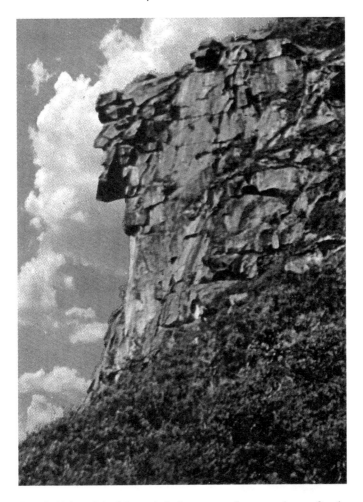

The Old Man of the Mountain is the most perfect natural stone face in the world—called "the Profile," the "Great Stone Face" of Hawthorne's story. On the south end of Profile Mountain (Cannon Mountain) rests the granite face fourteen hundred feet above beautiful Profile Lake.

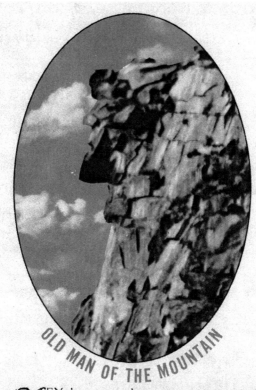

OLD MAN OF THE MOUNTAIN

MEN hang out their signs indicative of their respective trades. Shoemakers hang a gigantic shoe; jewelers a monster watch, even the dentist hangs out a gold tooth; but up in Franconia Mountains God Almighty has hung out a Sign to Show that in New England He Makes Men."

Daniel Webster.

FRANCONIA NOTCH, WHITE MOUNTAINS, N. H.

The Old Man of the Mountain postcard with caption.

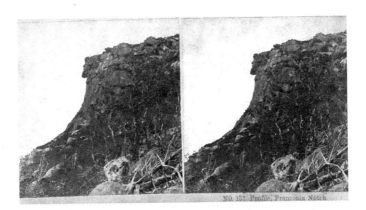

A distant view of the Old Man. In 1872, a group of Appalachian Mountain Club members were on top of the Old Man's head and discovered the precarious position of the upper of the two ledges that formed the forehead. The profile was in great danger of falling into the valley below.

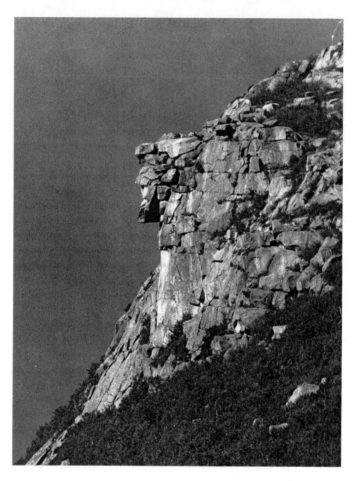

A view of the Old Man in Franconia Notch, New Hampshire. In 1906, thirty-four years after the 1872 discovery of the Old Man's trouble, Reverend Guy Roberts of Whitefield climbed and observed the condition. He was convinced that something must be done immediately.

Reverend Guy Roberts of Whitefield, New Hampshire, an abiding admirer of the Old Man, is credited with saving his life; he recorded for posterity in 1924 that the profile was discovered in the summer of 1805.

Franconia Notch

The Franconia Notch in the White Mountains of New Hampshire.
Looking north, we have an excellent view of the notch with the
quaint villages and farmhouses in the valley. This illustration is from a
lithograph after a drawing by George L. Brown Pinx.

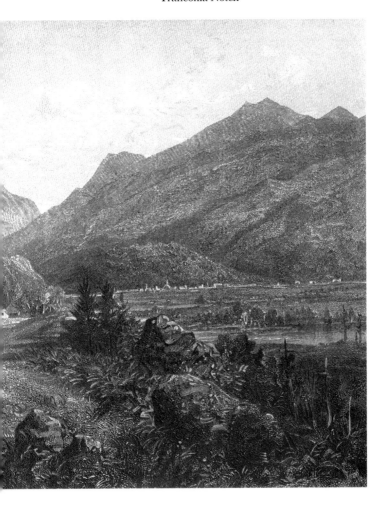

First time out on the Old Man, Cannon Mountain, Franconia Notch.

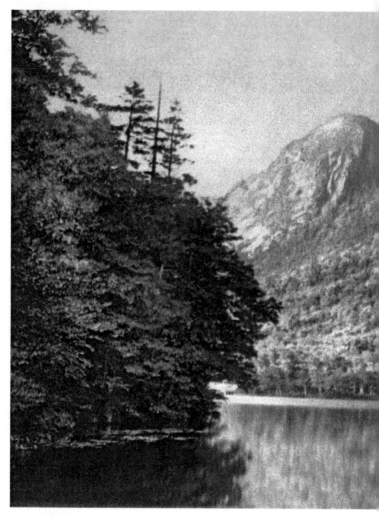

Eagle Cliff on Mount Lafayette, which looms above Profile Lake in Franconia Notch.

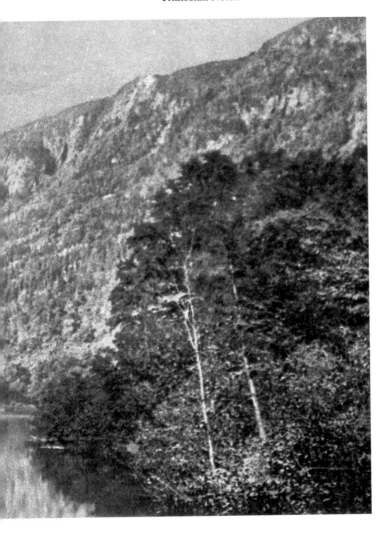

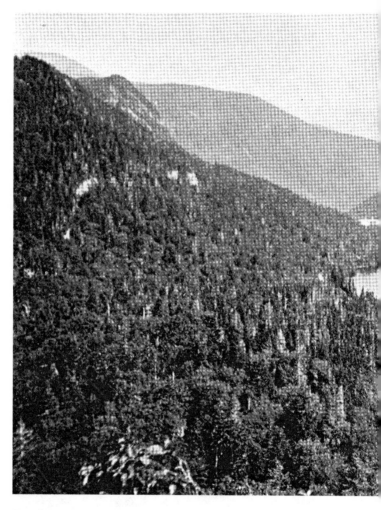

Echo Lake and Franconia Notch. The name itself breathes forth the free spirit of nature and sounds like the long rustle of pine boughs or the rush of sylvan streams through dewy thickets.

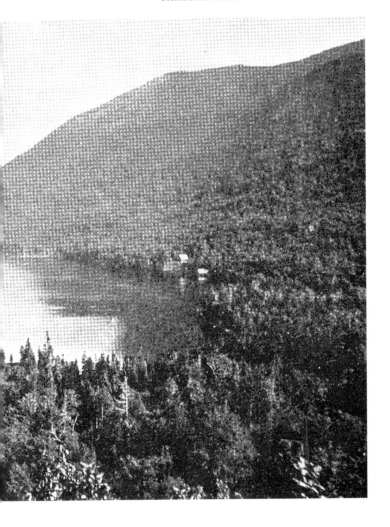

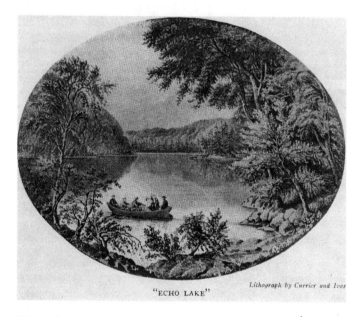

"ECHO LAKE"

Lithograph by Currier and Ives

Echo Lake, a bright, twenty-eight-acre mountain lake 1,940 feet above sea level, lies beneath the sheer granite walls of Eagle Cliff, which rises 1,500 feet above the lake.

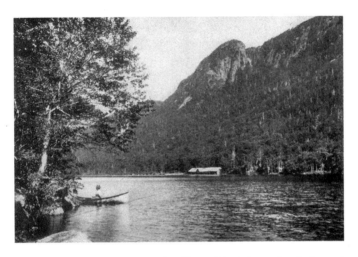

Profile Lake, Franconia Notch, New Hampshire, is located at the base of Profile Mountain. Born in Profile Lake and reenforced by long streams from the wilderness, this stream known as the Pemigewasset descends fifteen hundred feet in the first thirty miles of its course en route to the Merrimack River.

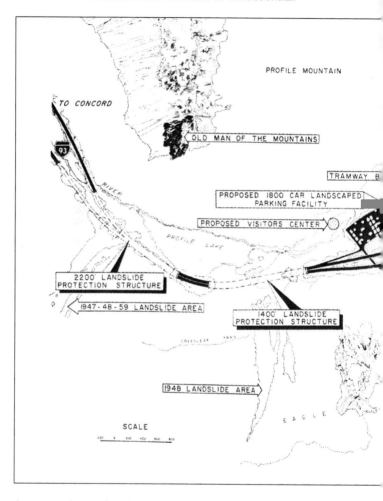

An approved route, I-93, known as the Franconia Parkway, runs through Franconia Notch, December 1968. This map indicates the placement of the Cannon Mountain ski slopes, the Old Man of the Mountain and landslide protection areas.

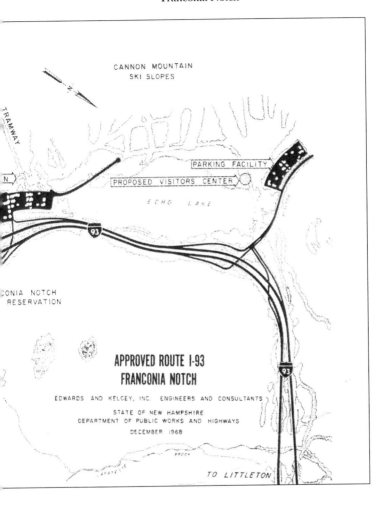

CANNON MOUNTAIN
SKI SLOPES

TRAMWAY

N

PARKING FACILITY

PROPOSED VISITORS CENTER

ECHO LAKE

93

CONIA NOTCH
RESERVATION

**APPROVED ROUTE I-93
FRANCONIA NOTCH**

EDWARDS AND KELCEY, INC. ENGINEERS AND CONSULTANTS

STATE OF NEW HAMPSHIRE
DEPARTMENT OF PUBLIC WORKS AND HIGHWAYS

DECEMBER 1968

93

TO LITTLETON

49

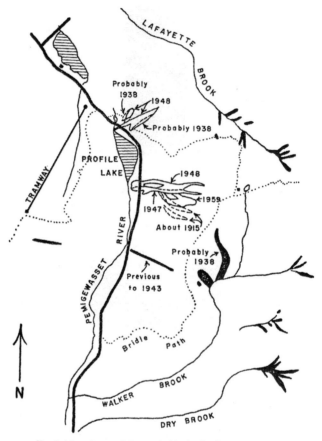

Sketch Map of part of Franconia Notch, showing area of greatest danger to road. Locations of past slides are shown, with dates of occurrence. Slides affecting road are merely outlined, to permit showing locations of previous slides at same sites; all others are inked solid.

Sketch map of part of Franconia Notch, which shows the past landslides, marked with arrows and dates, and indicates points of greatest danger to roadway.

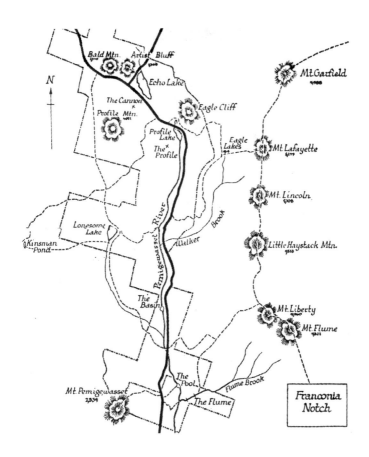

A map of Franconia Notch. What the Saco Valley is to the White Mountains, the Pemigewasset Valley is to the Franconia Range: the long and delightful vestibule through which access is gained to the many shadowy hills at the end.

Your Dollar Will Stop This

"Your Dollar Will Stop This." Published in the December 27, 1927 edition of the *Boston American*, this notice seeks $82,800 in contributions to preserve the "6,000 acres of woodland" that are "seriously threatened by the lumberman and his axe."

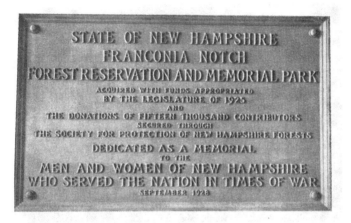

In September 1928, Franconia Notch State Park was dedicated as a memorial to "the men and women of New Hampshire who served the nation in times of war."

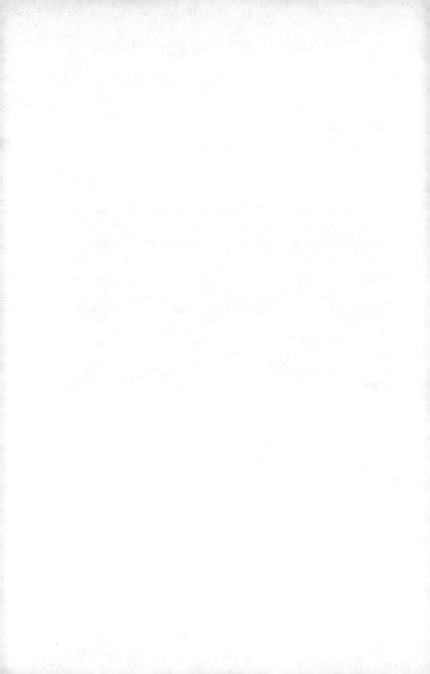

PRESERVATION OF THE OLD MAN OF THE MOUNTAIN

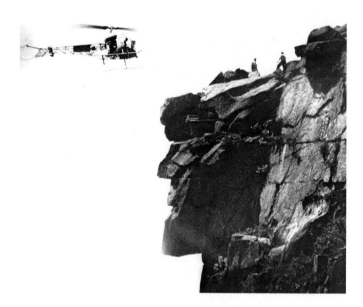

A close-up profile of the stone face with the helicopter used by Waterproof Products and Engineering during the 1958 repairs. The two volunteers on the brow of the profile are unknown.

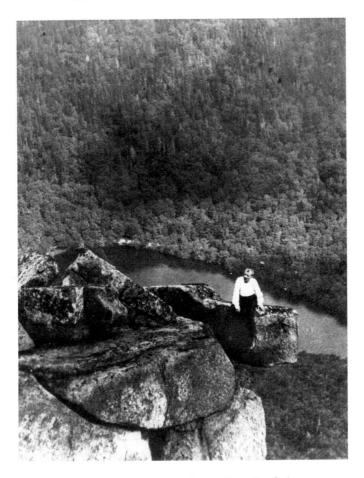

Edward H. Geddes, manager of the Quincy Quarries, Quincy, Massachusetts, is seen sitting on the outer edge of the slipping forehead stone. In 1915, he met with Reverend Roberts and became interested in the Old Man's trouble.

Seen here is the granite slab anchored to the forehead, circa 1916. The large boulder, estimated to weigh twenty-five tons, measures nineteen feet long and five feet wide. The small end is three feet, six inches deep; the back end is five feet, seven inches deep.

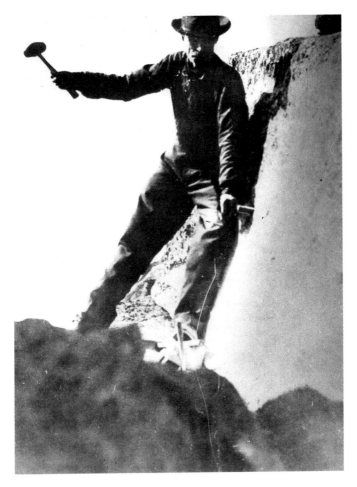

Edward Geddes expressed a willingness not only to place the turnbuckles in proper position, but also to do all the drilling necessary.

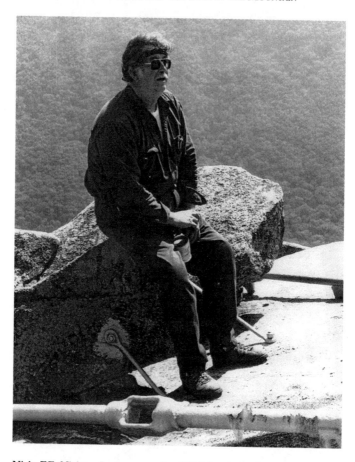

Niels F.F. Nielsen Jr. first saw the Old Man in 1947. In 1960, Niels became a state employee for the New Hampshire Public Works and Highway Department. Later that year, he joined the inspection party, making regular trips to examine the Old Man. He assumed leadership of the work party in 1965 and worked on the Old Man until 1990. In 1987, Governor John H. Sununu named him the first official caretaker of the Old Man of the Mountain.

The inspection crew, led by Caretaker Nielsen, is seen checking the turnbuckles. Niels and the Old Man were friends despite their age difference. *From left to right*: Niels F.F. Nielsen Jr., Deborah Nielsen, Robert Skinner, Mickey Libby (chief guide of Cannon Mountain) and David Nielsen.

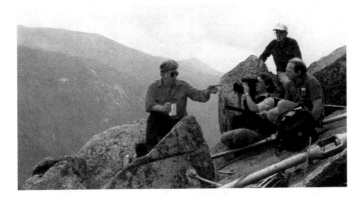

Niels F.F. Nielsen Jr., with coffee in hand, is talking with the press. *Left to right*: Nielsen Jr., *New Hampshire Crossroads* cameraman, John Grafera and William Ingham in the background.

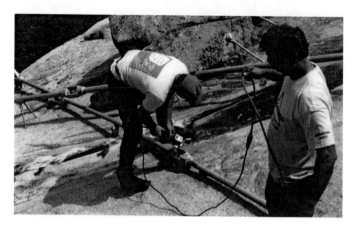

Crew members are checking the turnbuckles. *Left to right*: Bobbi Potter and Bradley Lawrence.

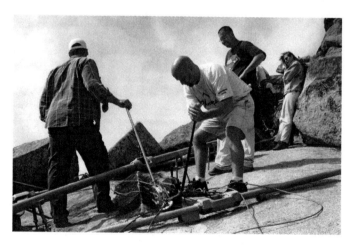

Crew members inspecting the turnbuckles. *Left to right*: Mark Goddard, Richard Bryant, Thomas Nielsen and an unknown reporter.

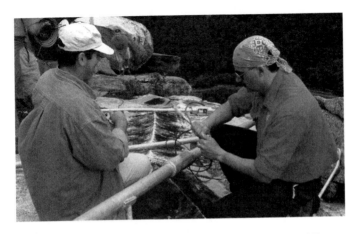

Inspecting the turnbuckles. *Left to right*: Mark Goddard, Richard Bryant and David Nielsen.

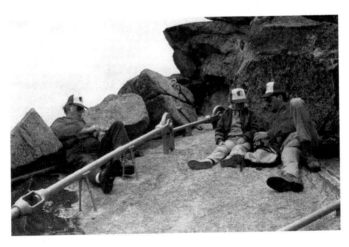

Niels, Thomas and David Nielsen having a moment of quiet relaxation on top of the profile. This was Thomas's first trip to the Old Man, 1987.

David Nielsen. In 1990, Niels F.F. Nielsen Jr. resigned as caretaker, and his son, David, with his wife Deborah as his assistant, was named as the new caretaker of the Old Man of the Mountain by Governor Gregg and confirmed by the Governor's Council in 1991.

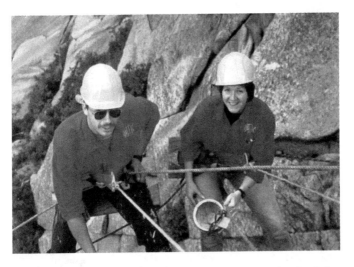

David and his wife, Deborah Nielsen, are hanging on the façade of the profile. Deborah was the only female who had ever gone over the edge of the Old Man of the Mountain.

David hangs off the end of the Old Man's chin while working with volunteers to repair the Old Man's Adam's apple.

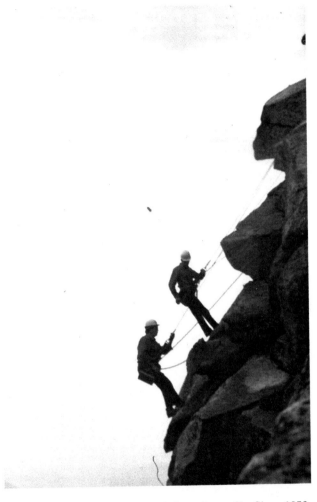

Niels and David are seen suspended on the profile. Since 1972, Niels, David and Deborah have measured the Old Man's face for possible movement.

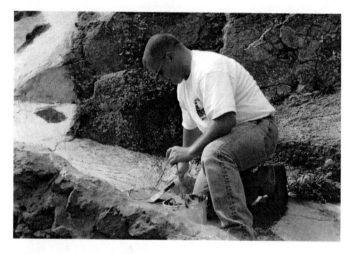

Terry Morgan is removing broken epoxy from the "sluiceway," which diverted water away from the Old Man.

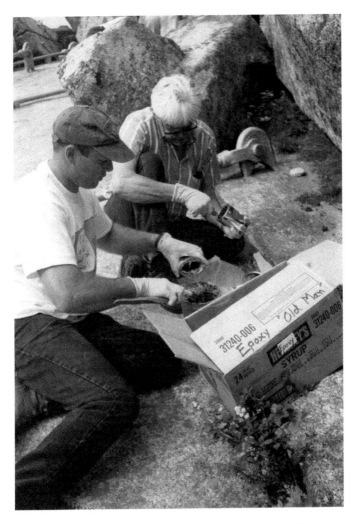

Robert Potter and Kenneth Colburn are preparing the epoxy for application.

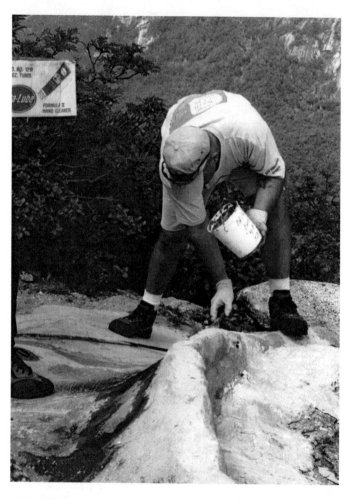

Richard Bryant applies epoxy to the sluiceway. He is seen covering the cracks and canopies of wire and fiberglass cloth, and then he recoated it four times with an epoxy mixture to prevent further debris and moisture from getting in.

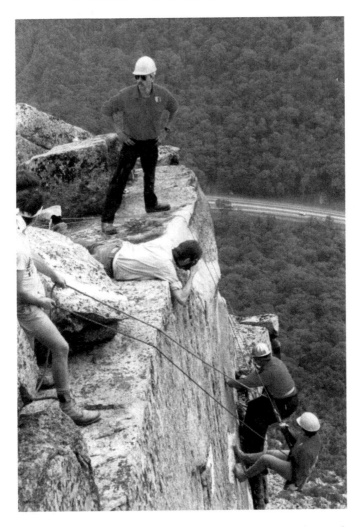

David Nielsen stands at the ready for Niels and Deborah as they work over the side.

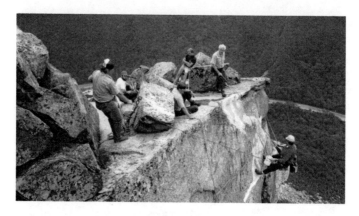

Gene Popion, Mike Cheever, Jack Harrison, an unknown reporter, Mickey Libby and Niels F.F. Nielsen Jr. Niels is seen placing epoxy on the south side of the Old Man's face.

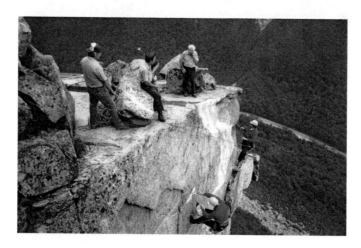

Gene Popion, Jack Harrison, Mickey Libby, Niels F.F. Nielsen Jr. and David Nielsen clear and measure the Old Man.

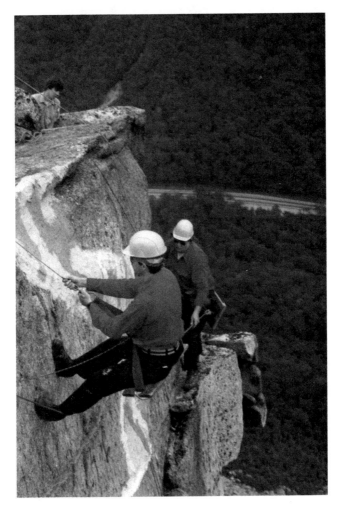

David and Niels F.F. Nielsen Jr. are seen cleaning and measuring the
Old Man.

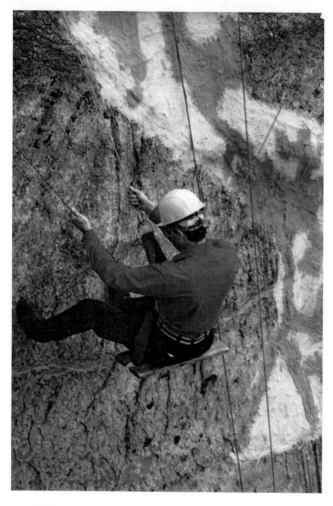

David Nielsen is seen alone on the profile, taking measurements of the Old Man.

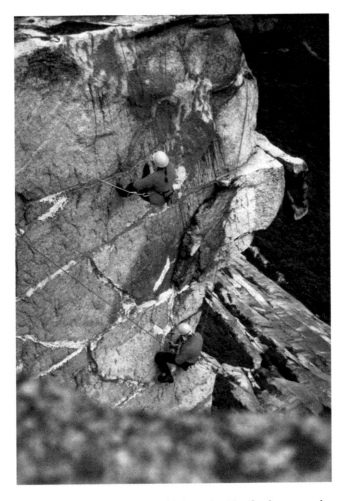

Deborah Nielsen is above David Nielsen, checking for damage to the south side.

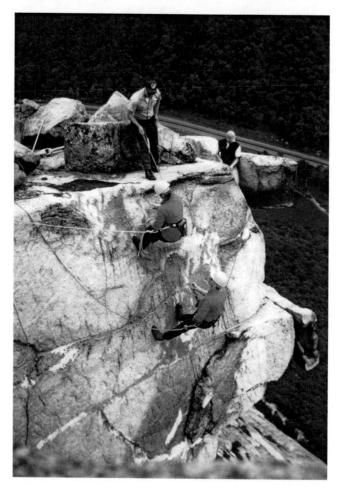

Michael Pelchat is on top of the Old Man as William Whitcher stands near the forehead. Deborah and David are climbing up the south side.

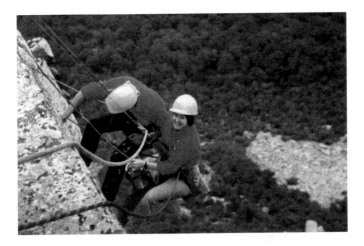

David and Deborah are seen placing epoxy into the south side of the Old Man's face.

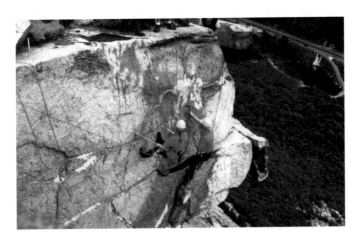

Deborah and David inspect and test the south side membrane.

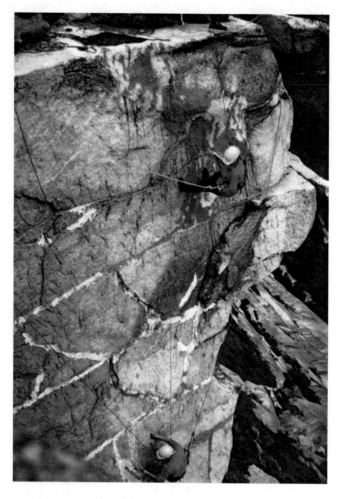

Deborah and David measure two of the fourteen checkpoints used to monitor the movement of the Old Man.

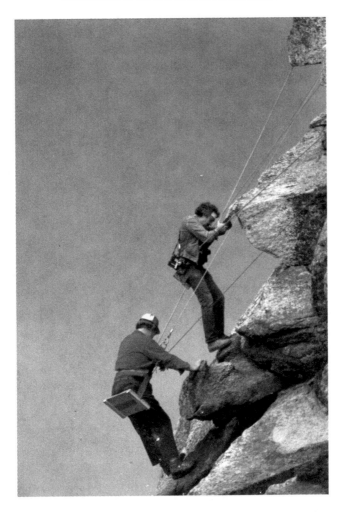

Niels F.F. Nielsen Jr. is showing the face to Peter B. Kaplan (photographer for *People* magazine). Kaplan is the only professional photographer ever to shoot over the edge of the Old Man with the Nielsens.

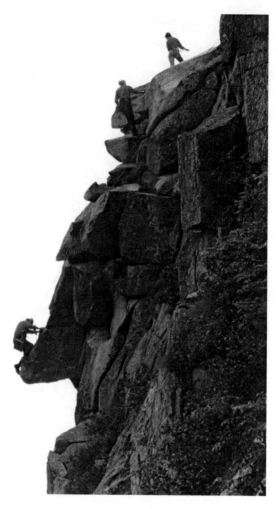

Deborah, David and Niels are measuring the front face of the Old Man. In this position, they would take measurements and shout them to Deborah, who usually sat just above the forehead to write them down.

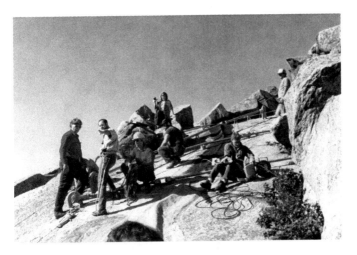

Niels, a *Today Show* cameraman, David, Mike Cheever, Deborah and a *Today Show* sound man. The Old Man's greatest danger was from people who took the tramway to the top of the mountain and hiked half a mile to the profile. They wanted to bring back souvenirs.

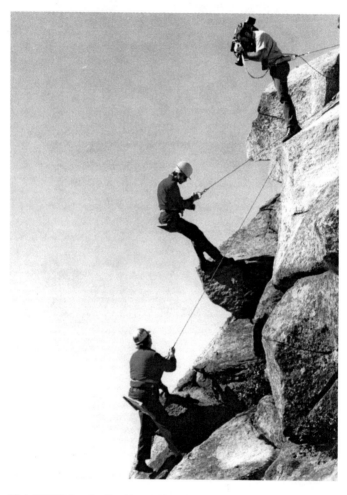

Niels F.F. Nielsen Jr., David and *Today Show* cameraman. They are seen making preparations for the work over the side. Measurements from the profile would be compared with those of previous years.

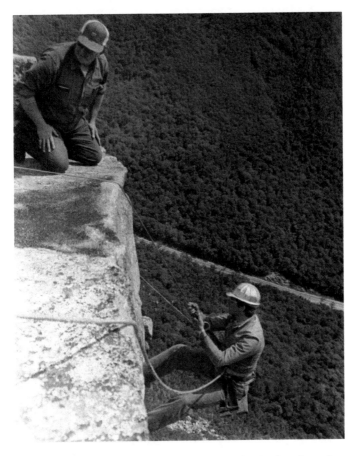

David Nielsen is seen descending over the edge for the first time, circa 1976. *Photo by Dick Hamilton, White Mountain News Bureau, No. Woodstock, New Hampshire, 03262.*

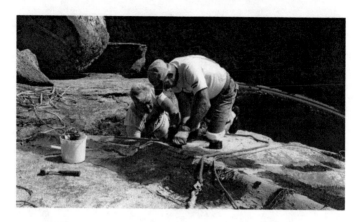

Ronald Mitchell and George Clough, longtime volunteers, are repairing the canopy on top of the Old Man's head. Vandals would pry loose rocks and epoxy; eventually, initials were carved in the carefully placed canopies, letting moisture in and undoing the preservation efforts.

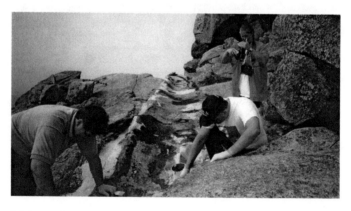

Michael Nielsen, David Nielsen and Deborah Nielsen work on the "sluiceway." "I believe we are gaining in our battle with nature and the violent elements," announces Niels F.F. Nielsen Jr.

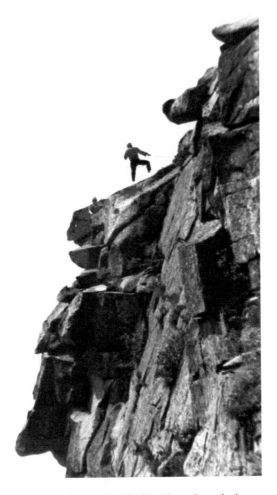

Niels is standing near the forehead, while David stands on the brow, preparing to descend. The condition of the Old Man continued to change, and the crew continued to patch him up as best they could.

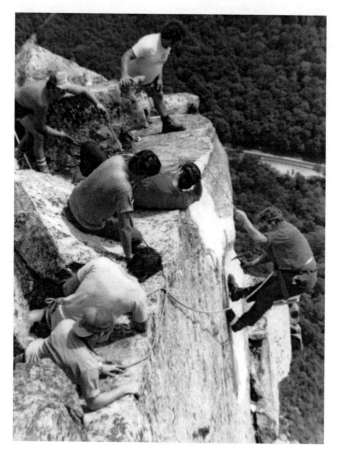

Niels inspects the south side while David and Parks employees look on. "The battle that we are losing is with thoughtless vandals who continue to carve initials in the semisoft membranes and destroy vital testing equipment," said Niels F.F. Nielsen Jr. He continued, "The Old Man walks. It heaves and sighs with changes in temperature and vibration. It is extremely sensitive to vibration, shivering even to the rumbling truck on the highway some 1,400 feet below."

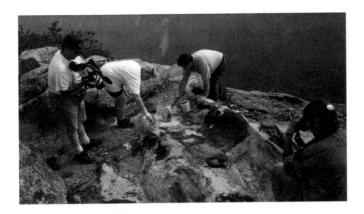

Ron Ketchie (cameraman for *Outdoors*, with Bob), Brenda Mento, Michael Nielsen and Deborah Nielsen are cleaning the sluiceway and documenting the work.

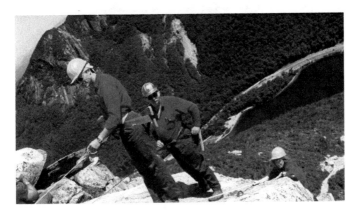

David, Niels and Deborah Nielsen are seen tending to their inspection on the Old Man. Over the many decades, the caretaker would place many checkpoints in the rocks at the top and on the face itself, by which he could measure shifts in position.

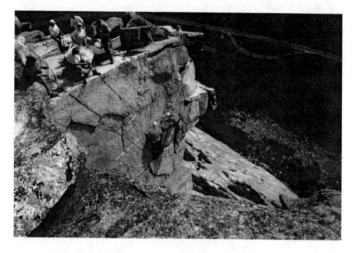

David and Deborah are suspended two hundred feet above the ground while volunteers guide their lifeline. No one can predict just when the Old Man will pass from view. It could last for centuries or a decade. An earth tremor could take him in an instant.

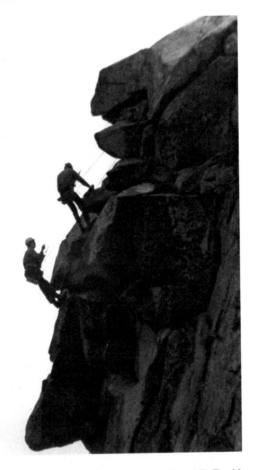

Niels F.F. Nielsen Jr. stands on the Old Man's upper lip, while David is seen standing in the Old Man's left eye, some five hundred feet above the ground on the front side of the Old Man. Niels F.F. Nielsen Jr. announced that "if the Old Man can be preserved for even one extra generation's view, then all the past, present and future efforts will have been worthwhile."

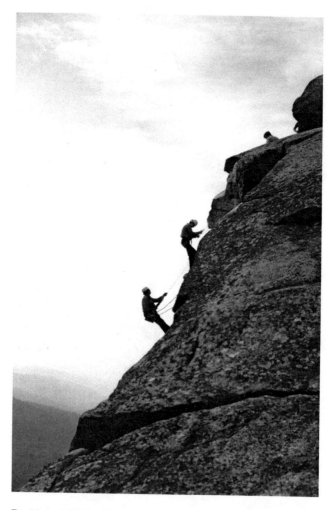

David and Niels F.F. Nielsen Jr. are seen suspended on the profile. While the Old Man owes its creation to nature, it owes its preservation in great part to one family—the Nielsens.

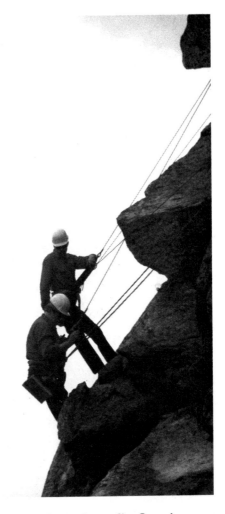

David and Niels F.F. Nielsen Jr. on the profile. Over the years, the same forces that carved out the face—ice, wind, weather and water—have threatened to destroy it.

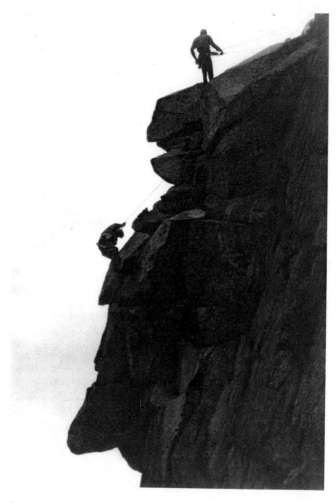

David and Niels F.F. Nielsen Jr. are seen on the profile. David is on the forehead while Niels is on the nose of the Old Man.

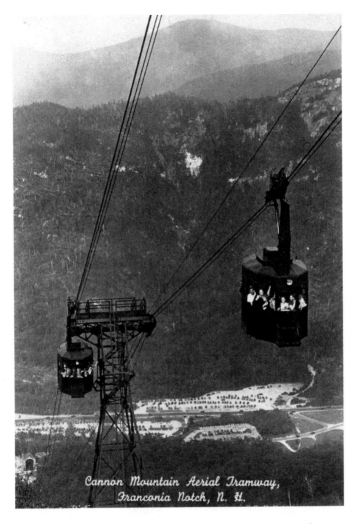

Cannon Mountain Aerial Tramway,
Franconia Notch, N. H.

The aerial tramway, as seen on the southeastern shoulder of Cannon Mountain, traveling to the summit.

Preparing the day's gear and ascent to the profile.

Preparing the gear and ascent.

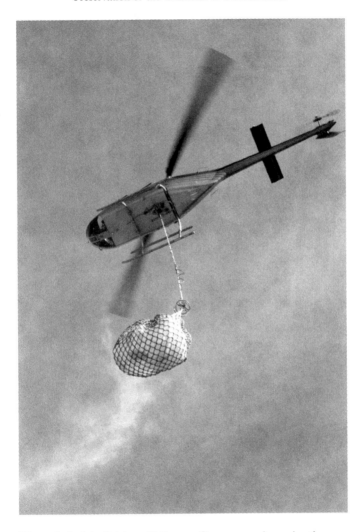

The arrival of the Brigham Helicopter Company and carrying the supplies and gear to the summit.

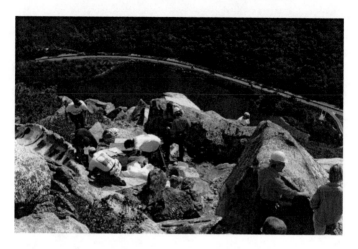

Volunteers for the day unpack the equipment and prepare various jobs. David speaks with a reporter.

The helicopter pad.

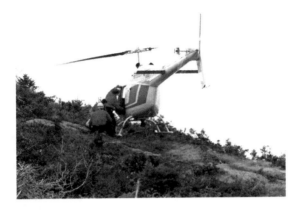

The drop-off by Brigham Helicopter Company before the landing pad was built.

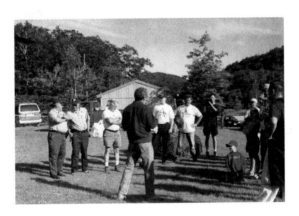

The safety lecture by pilot Carl Swenson of Brigham Helicopter Company. Included in the picture are Joel Peabody, Mike Pelchat, Ronald Mitchell, Joel Dinsmore, Bradly Lawrence, an unknown cameraman, the children of Bobbi Potter, Richard Bryant and Thomas Nielsen.

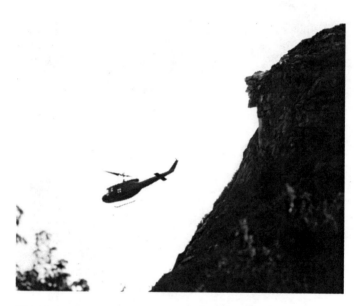

The National Guard helicopter circling the Old Man.

MOMENTS OF REFLECTION

Thomas, Deborah and David share a postcard moment on the forehead.

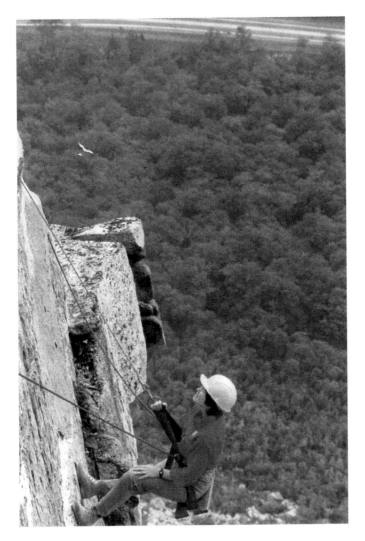

Deborah is suspended—her first solo drop.

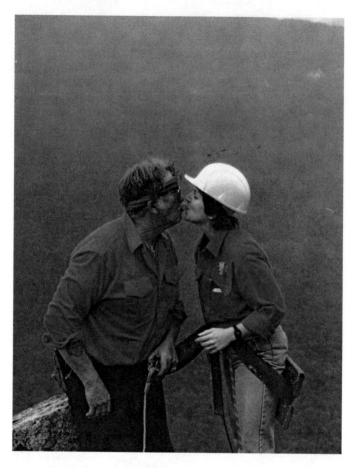

Deborah gets a kiss from Niels after her first trip over the side. This was documented by *New Hampshire Crossroads*.

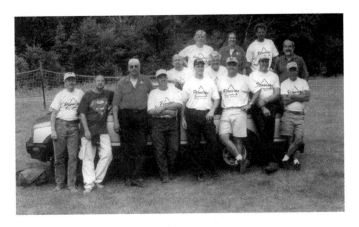

Volunteers for the preservation of the Old Man. *From left to right, first row*: John Martinsen, Thomas Nielsen, David Nielsen, Mark Goddard, Joel Dinsmore, unknown, Robert Potter and George Clough. *Left to right, second row*: Rochard Bryant, Ronald Mitchell and Carl Swenson. *Left to right, third row*: Brenda Mento, Deborah Nielsen and Bradley Lawrence.

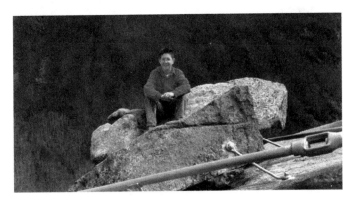

Thomas B. Nielsen, son of David Nielsen, is sitting on "Pop's rock" of the Old Man, with the valley far below.

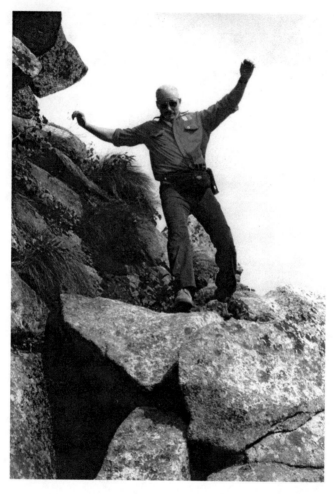

David Nielsen, caretaker of the Old Man, is jumping across "decision rock."

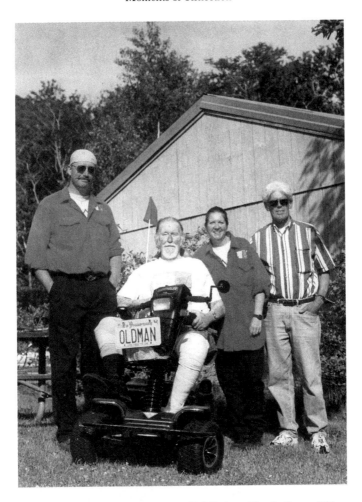

The special Old Man number plate officially issued by the State of New Hampshire. *Left to right*: David, Niels, Deborah and Kenneth Colburn. Just because Niels could not climb did not mean that he could not be in attendance for the annual trip to the Old Man.

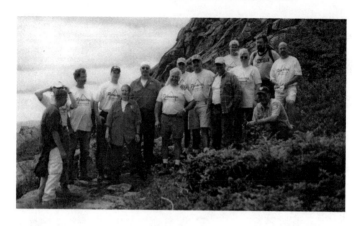

Special volunteers. *Left to right*: Thomas Nielsen, John Martinsen, Bradley Lawrence, Joel Dinsmore, Deborah Nielsen, David Nielsen, Ronald Mitchell, George Clough, unknown, Mark Goddard, Bobbi Potter, Brenda Mento, unknown, Richard Bryant and Michael Pelchat (kneeling).

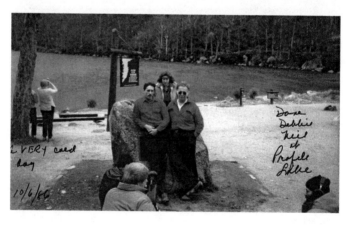

Posing at Profile Lake during a WBZ-TV interview: David, Deborah and Niels F.F. Nielsen Jr., October 6, 1980.

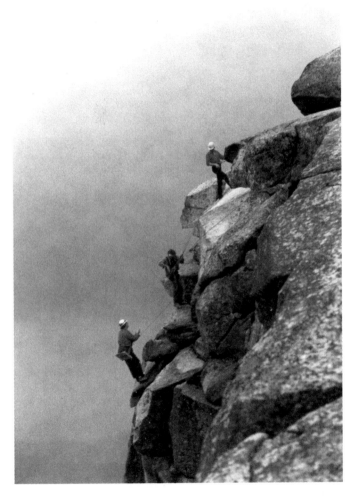

A family affair suspended on the profile of the Old Man: Niels F.F. Nielsen Jr., Peter B. Kaplan and David.

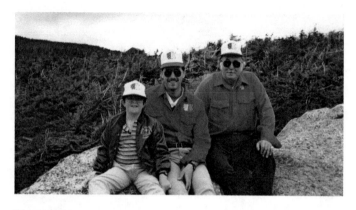

This is the first picture of the three generations of caretakers: Thomas, David and Niels F.F. Nielsen Jr.

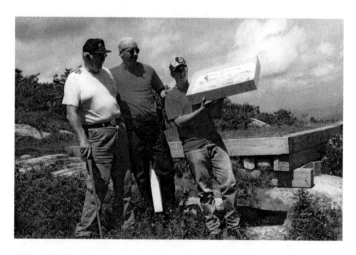

Niels F.F. Nielsen Jr., David Nielsen and Thomas Nielsen prepare to celebrate "Pop's Birthday Cake" on top of the Old Man. The rest of the crew also got some cake.

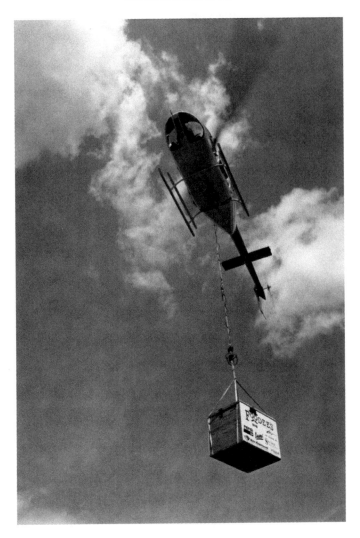

Foodee's—thanks for the pizza!

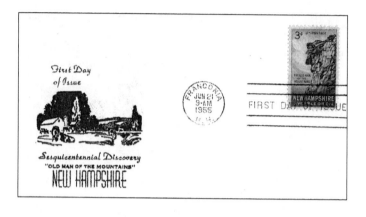

...... AND UP IN FRANCONIA, GOD ALMIGHTY HAS HUNG OUT A SIGN THAT IN NEW ENGLAND HE MAKES MEN." D. WEBSTER

Above: "First Day Issue" envelope celebrating the Old Man.

Left: Chippa Granite with President Dwight D. Eisenhower. Artist Alice Cosgrove renders this cartoon for publicity of the upcoming celebration of the Old Man. President Dwight D. Eisenhower was the featured speaker at the ceremonies that marked the sesquicentennial of the discovery of the stone face, held near Profile Lake on June 24, 1955.

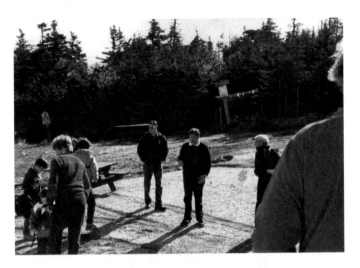

Governor Sununu and family make a visit to Franconia Notch.

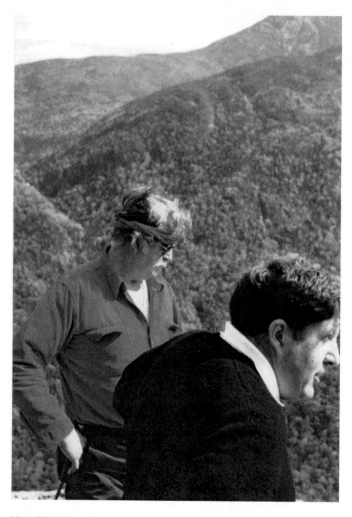

Niels F.F. Nielsen Jr. and Governor Sununu are seen on the forehead of the Old Man as they look down the Franconia Valley below.

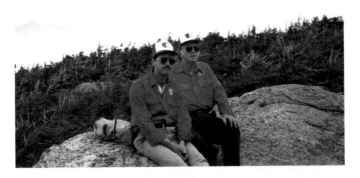

Father and son—David and Niels F.F. Nielsen Jr. ("Pop")—caretakers of
the Old Man of the Mountain.

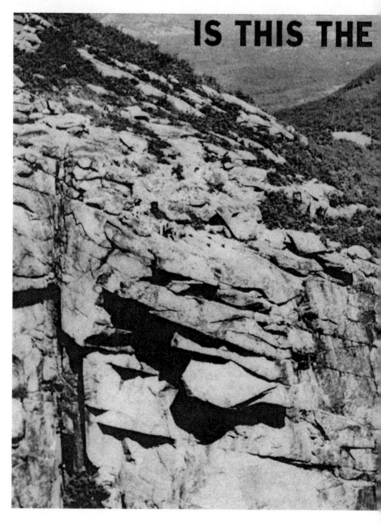

IS THIS THE

The profile as seen head on—five slabs are clearly visible. The Old Man became the official emblem for the state of New Hampshire in 1945.

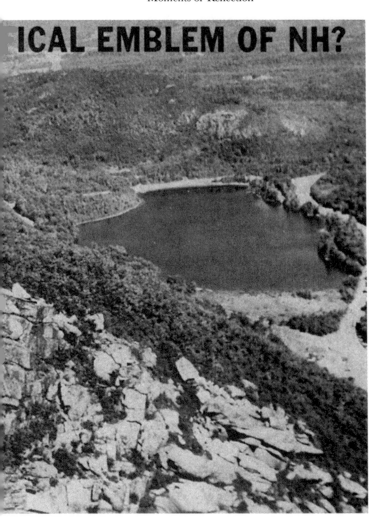

At the Old Man's doorstep is Mickey Libby, chief guide for Cannon Mountain.

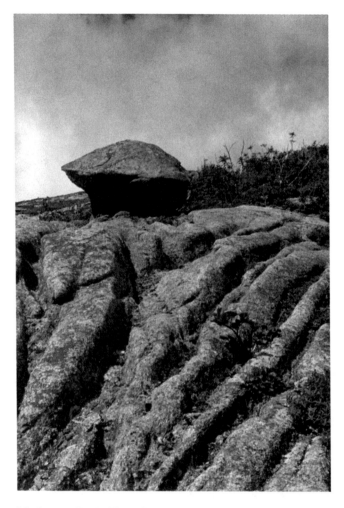

Mushroom Rock. The effect of years of acid rain are shown clearly here.

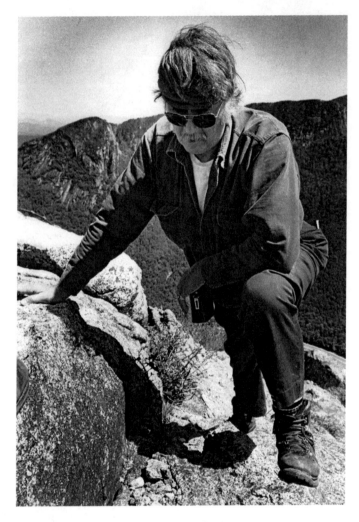

Niels F.F. Nielsen Jr. inspects Mushroom Rock.

'The
OLD MAN
of the
MOUNTAINS'

*An
American
Landmark
for
150
years . . .*

Scenic Grandeur in NEW HAMPSHIRE

This summer visit NEW HAMPSHIRE and join in the Jubilee Celebration commemorating the discovery of the Old Man of the Mountains 150 years ago. Endless opportunities for rest and recreation away from the strain of city life! Plunging falls and cloud-tipped mountain-peaks ... Placid lakes and shady forest groves ... Fine old inns or modern resorts unmatched for comfort and hospitality ... A vacation you'll never forget in glorious NEW HAMPSHIRE.

Write for FREE 'Vacation Guide'

STATE PLANNING and DEVELOPMENT COMMISSION

Advertisement from the State Planning and Development Commission.

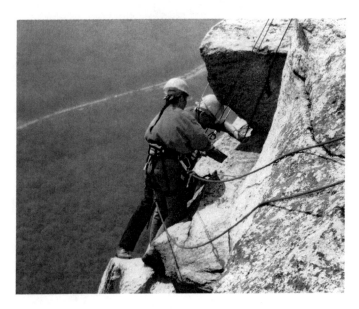

David and Deborah are seen placing half of the ashes of Niels F.F. Nielsen Jr. into the Old Man's left eye, circa 2002. This was one of Niels's last wishes.

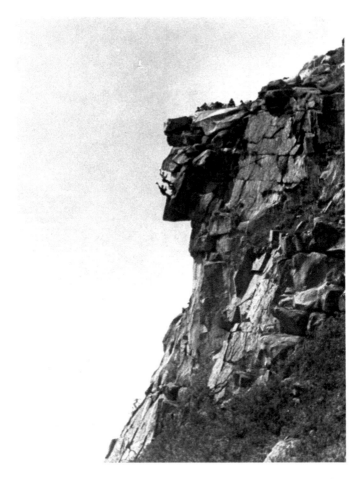

"Lean back and wave." Goodbye Old Man. On May 3, 2003, the Old Man fell, but his memory will be celebrated for many years to come.

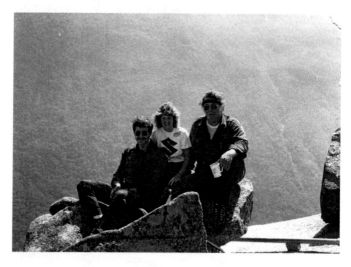

The Nielsen family would like to thank you for letting them take care of your Old Man.

Chronology

1805 The Old Man was discovered by L. Brooks and F. Whitcomb, surveyors.

1820 The road through Franconia Notch attracts more visitors.

1853 First of the three Profile Houses was built—all burned down, the last in 1923.

1872 Appalachian Mountain Club found that the "Forehead" stone was slipping.

1905 Reverend Guy Roberts noted further movement of the stone profile.

1915 Reverend Roberts and Ed Geddes checked site and designed the fasteners.

1916 Geddes fastened "Forehead" with Half Lewis.

1925 Owners decided to sell six thousand acres for $400,000.

1925 The state legislature appropriated $200,000.

The Society for the Protection of New Hampshire Forests gave $100,000.

The New Hampshire Federation of Women's Clubs raised the last $100,000.

1928 The land of Franconia Notch was dedicated as a State Forest Reservation and Park.

1937 Ed Geddes checked the Old Man for the last time— no movement.

1945 The Old Man became the official emblem of New Hampshire.

1946 The State of New Hampshire appropriated $25,000 for work to protect the Old Man.

1954 Hikers found widening of crack across the top of the head.

Further inspection found that the crack Geddes had spoken of in 1937 had indeed widened by three-fourths of an inch. The Old Man needed help.

1955 A bill was introduced into the New Hampshire legislature to appropriate $25,000 for the repair of the Old Man of the Mountain.

1957 Legislature authorized major repairs. President Dwight D. Eisenhower visited the profile as part of the Old Man's 150th birthday.

1958 Waterproofing Engineering & Products Company had the low bid of $9,889.

Work started July 21 and was completed October 20.

1959 The state insulated tie rods and installed strain gauges.

1960 Niels F.F. Nielsen Jr. joined the inspection party—checked gauges and tender, loving care.

1965 Niels F.F. Nielsen Jr. became the leader of the work parties.

1968 The three oldest sons, Tom, Bob and Mike Nielsen, joined their dad in the profile's inspection.

1969 Nielsen's youngest son, David, made his first of many trips to the Old Man.

1971 Niels F.F .Nielsen Jr.'s first trip over the side—cleaned the cracks in south face.

1972 Niels F.F. Nielsen Jr. sealed the south face with epoxy and installed checkpoints in face.

1976 David made his first trip over the edge of the Old Man.

1983 Deborah Goddard made her first trip to the Old Man with David. They were married in 1984 and became partners on and off the mountain.

1986 Representative Niels F.F. Nielsen Jr. sponsored a change in the state's vandalism law to include damage to the Old Man of the Mountain.

1987 Niels F.F. Nielsen was named the first official caretaker of the Old Man of the Mountain by Governor John H. Sununu.

1990 Niels F.F. Nielsen Jr.'s last trip down on the Old Man's face.

1991 Niels F.F. Nielsen Jr. resigned as caretaker and son David was named caretaker by Governor Gregg and confirmed by the Governor's Council.

1993 The Old Man of the Mountain Museum and Preservation Association was incorporated.

1996 On June 17, a groundbreaking and dedication ceremony was held at the new museum site in the Franconia State Park.

2000 The U.S. Mint placed the Old Man of the Mountain on the quarter that represents New Hampshire.

2001 Niels F.F. Nielsen Jr. passed away.

2002 In July, David and Deborah Nielsen placed half of the ashes of Niels F.F. Nielsen Jr. into the Old Man's left eye. This was one of the last wishes of Niels.

2003 On May 3, the Old Man fell from the mountain.

Visit us at
www.historypress.net